SEURAT COLORING BOOK

8 Paintings from the Master

ARTHUR BENJAMIN

©Copyright, 2017, by Arthur Benjamin and Maestro Publishing Group
All rights reserved.

No part of this book may be reproduced or transmitted in any form or by any means, electronic or mechanical, including photocopying, recording or by any information storage and retrieval system, without permission in writing of the copyright owner.

Printed in the United States of America

CONTENTS

Plate 1. *Le Chahut*, 1889–90, Kröller-Müller Museum, Otterlo ... 5

Plate 2. *A Sunday Afternoon on the Island of La Grande Jatte*, 1884–86, Art Institute of Chicago 7

Plate 3. *Young Woman Powdering Herself*, 1888–90, Courtauld Institute of Art .. 9

Plate 4. *Fishing in The Seine*, 1883, Musée d'art moderne de Troyes .. 11

Plate 5. *The Laborers*, 1883, National Gallery of Art Washington, DC. .. 13

Plate 6. *Bathers at Asnières*, 1884, National Gallery, London .. 15

Plate 7. *The Circus*, 1891, Musée d'Orsay, Paris .. 17

Plate 8. *Gray Weather*, 1888, Philadelphia Museum of Art ... 19

ABOUT THE BOOK

Seurat was one of the greatest artists of his time. Discover some of his greatest masterpieces through this gorgeously illustrated collection of paintings formatted specifically for coloring.

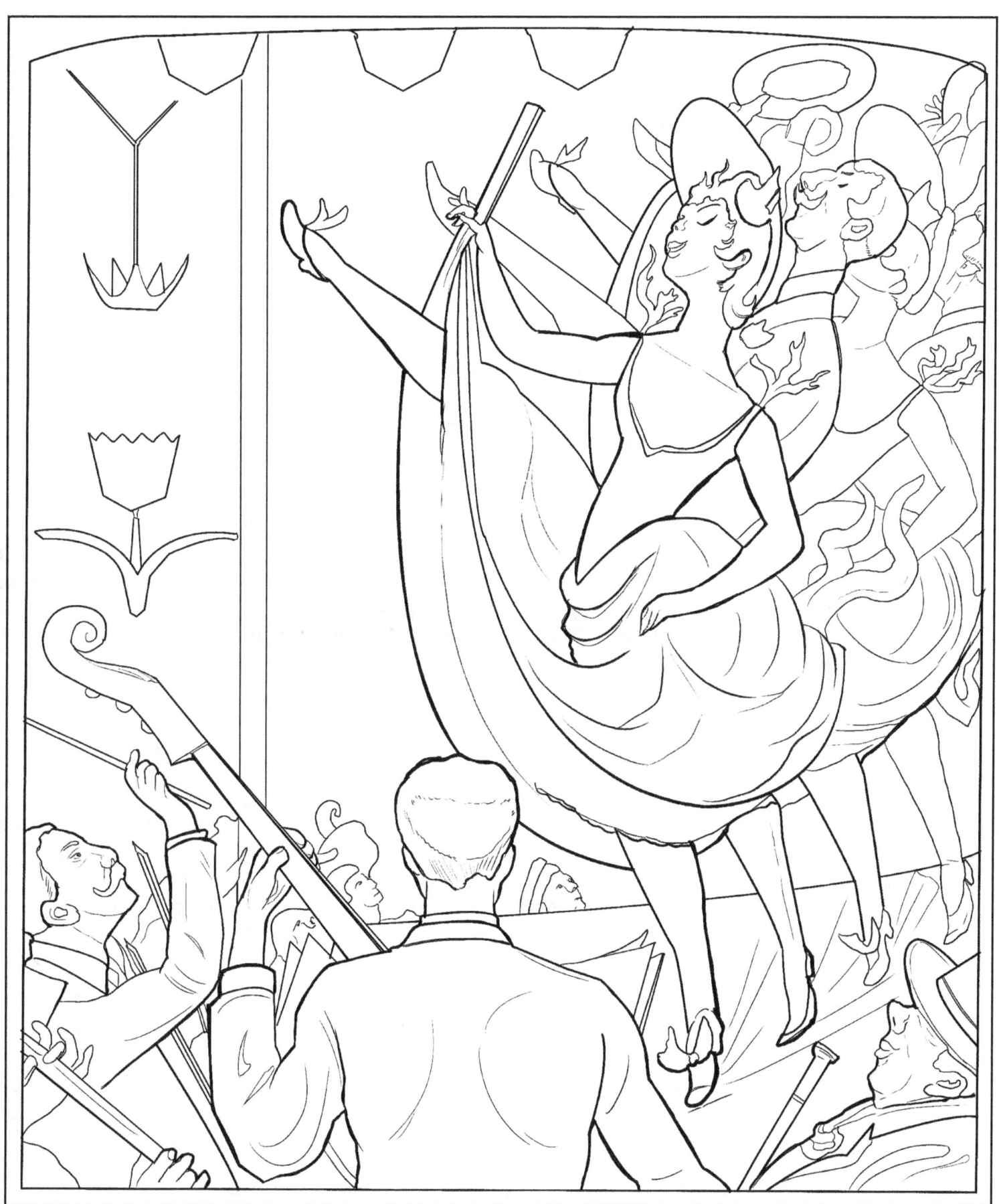

Plate 1.

Le Chahut, 1889–90, Kröller-Müller Museum, Otterlo

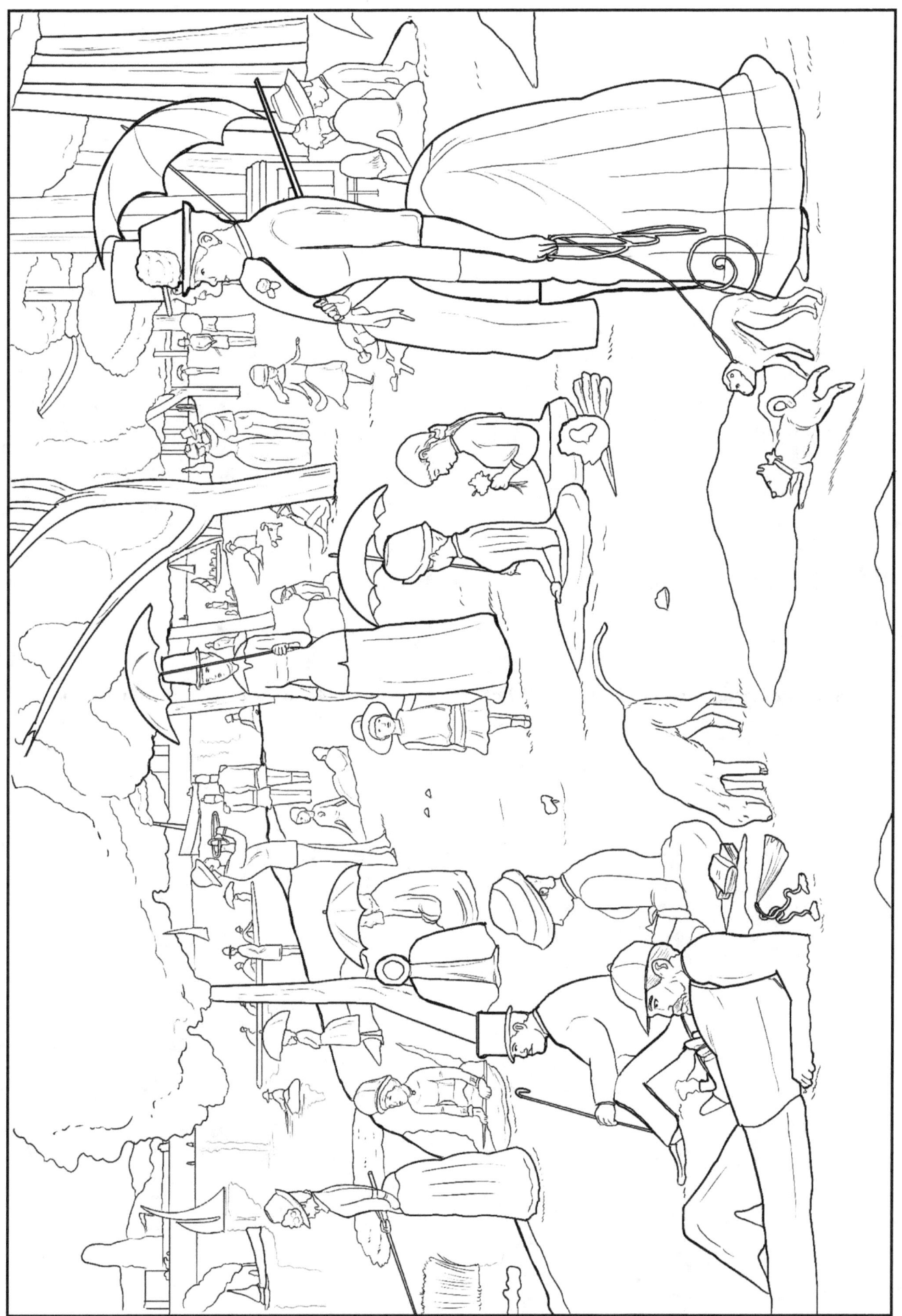

Plate 2.

A Sunday Afternoon on the Island of La Grande Jatte, 1884–86, Art Institute of Chicago

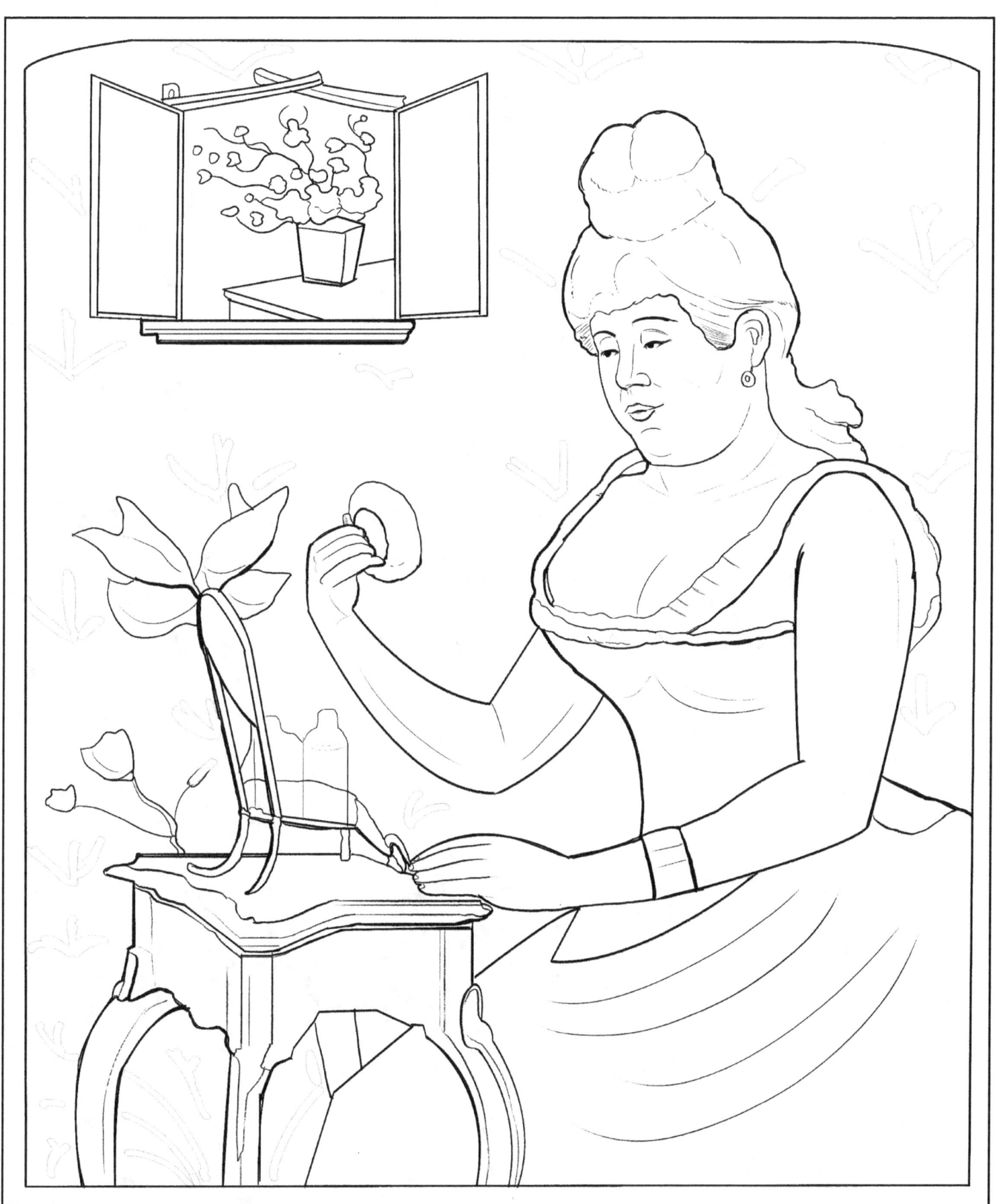

Plate 3.

Young Woman Powdering Herself, 1888–90, Courtauld Institute of Art

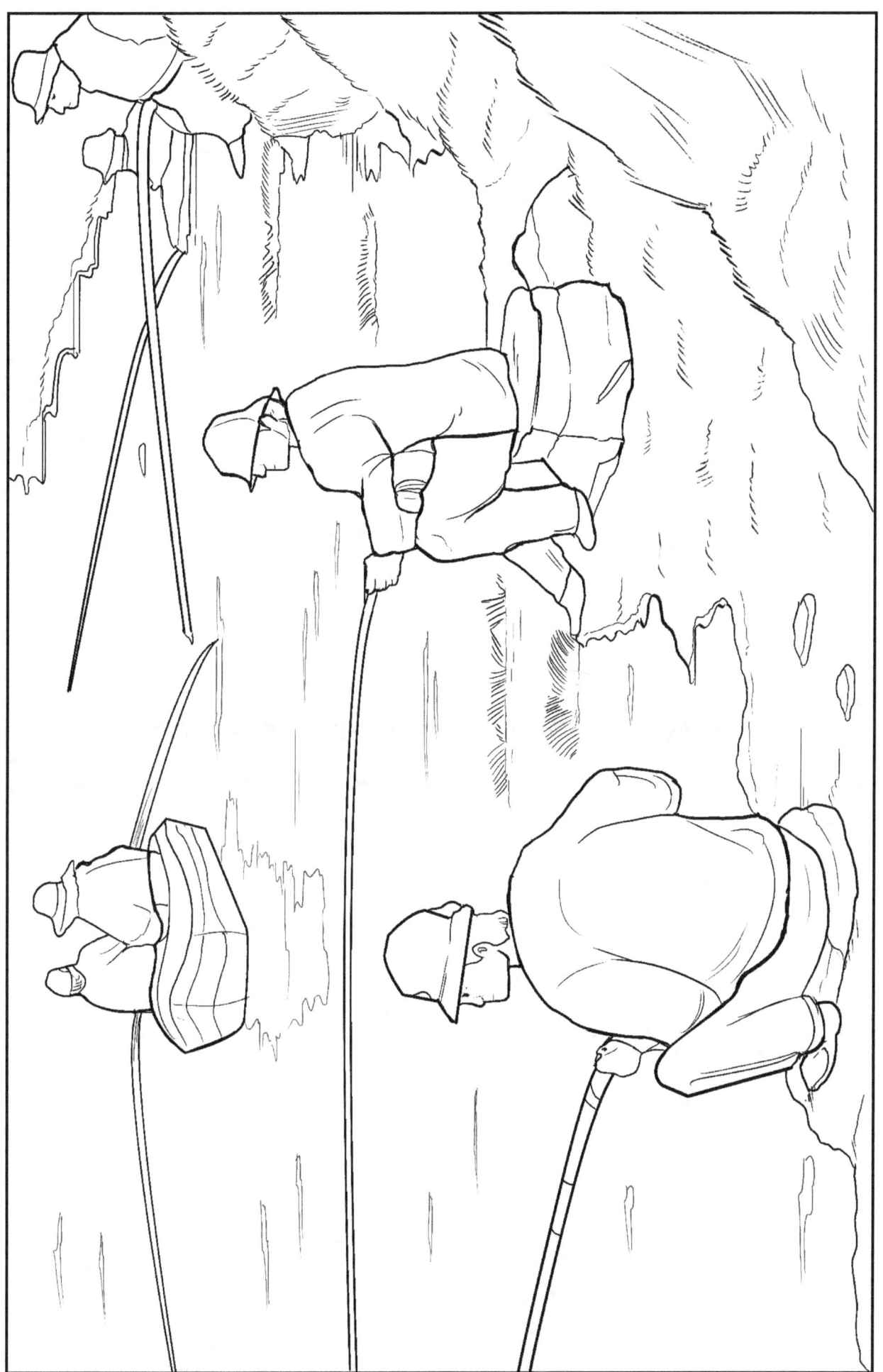

Plate 4.

Fishing in The Seine, 1883, Musée d'art moderne de Troyes

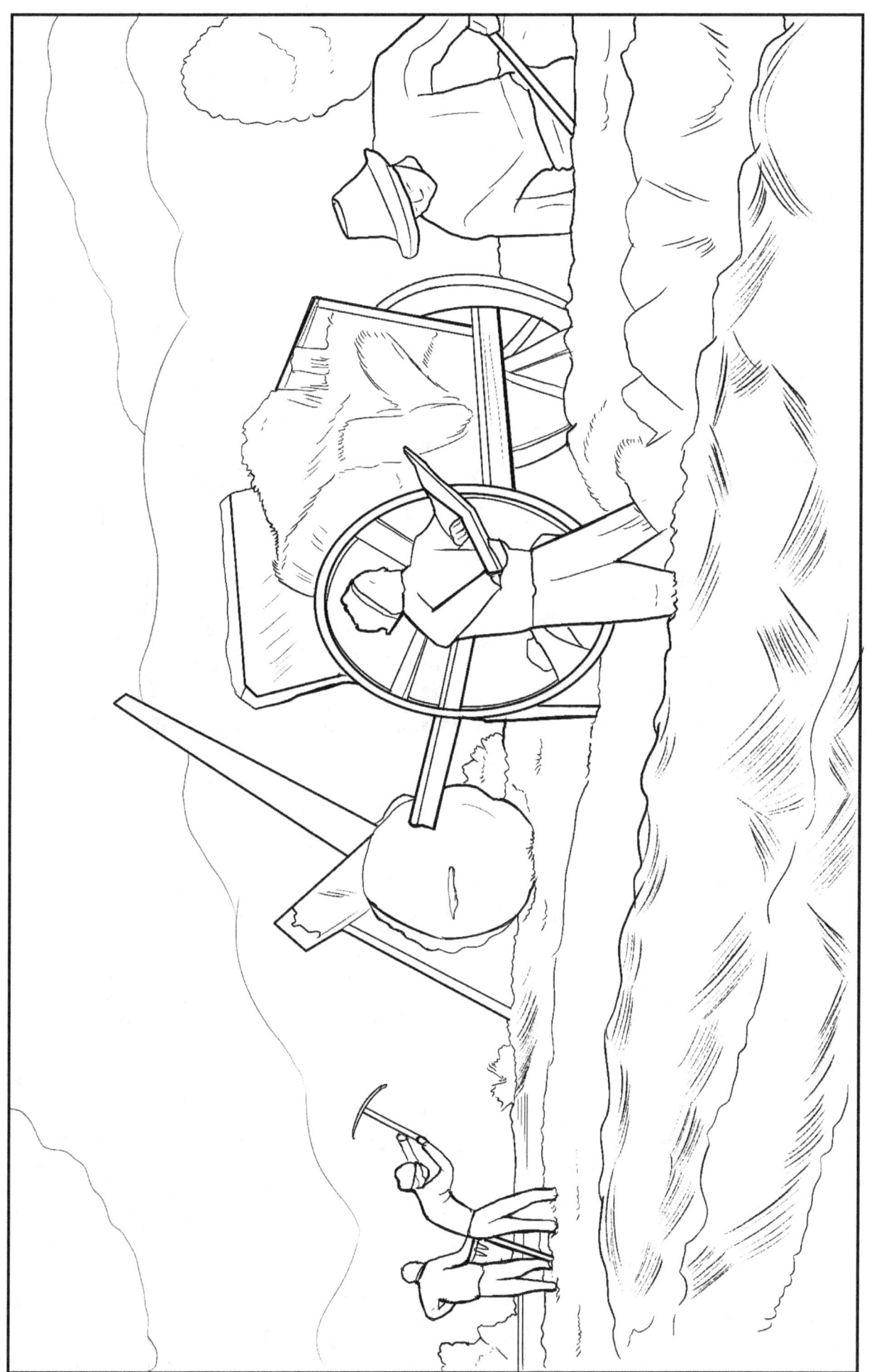

Plate 5.

The Laborers, 1883, National Gallery of Art Washington, DC

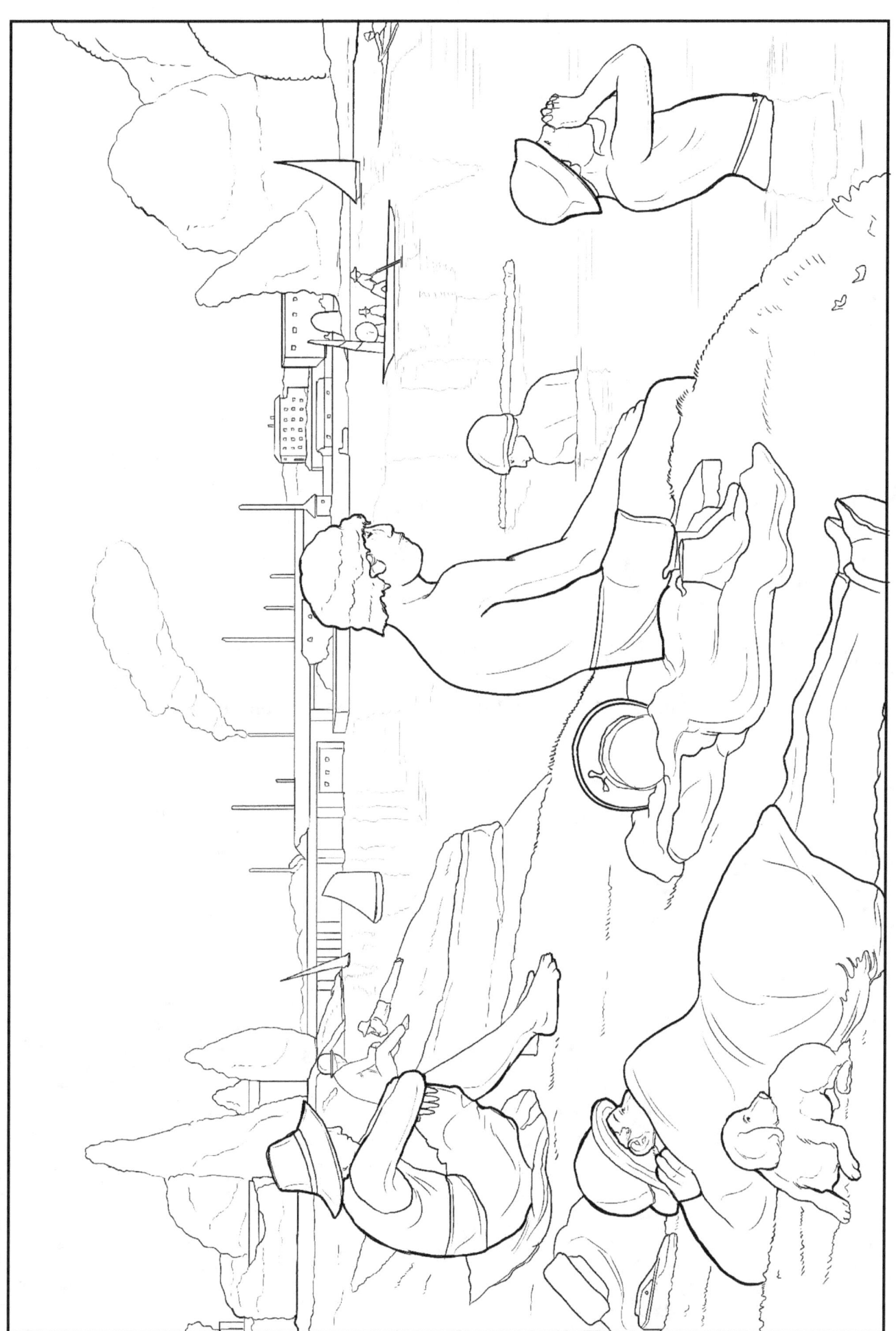

Plate 6.

Bathers at Asnières, 1884, National Gallery, London

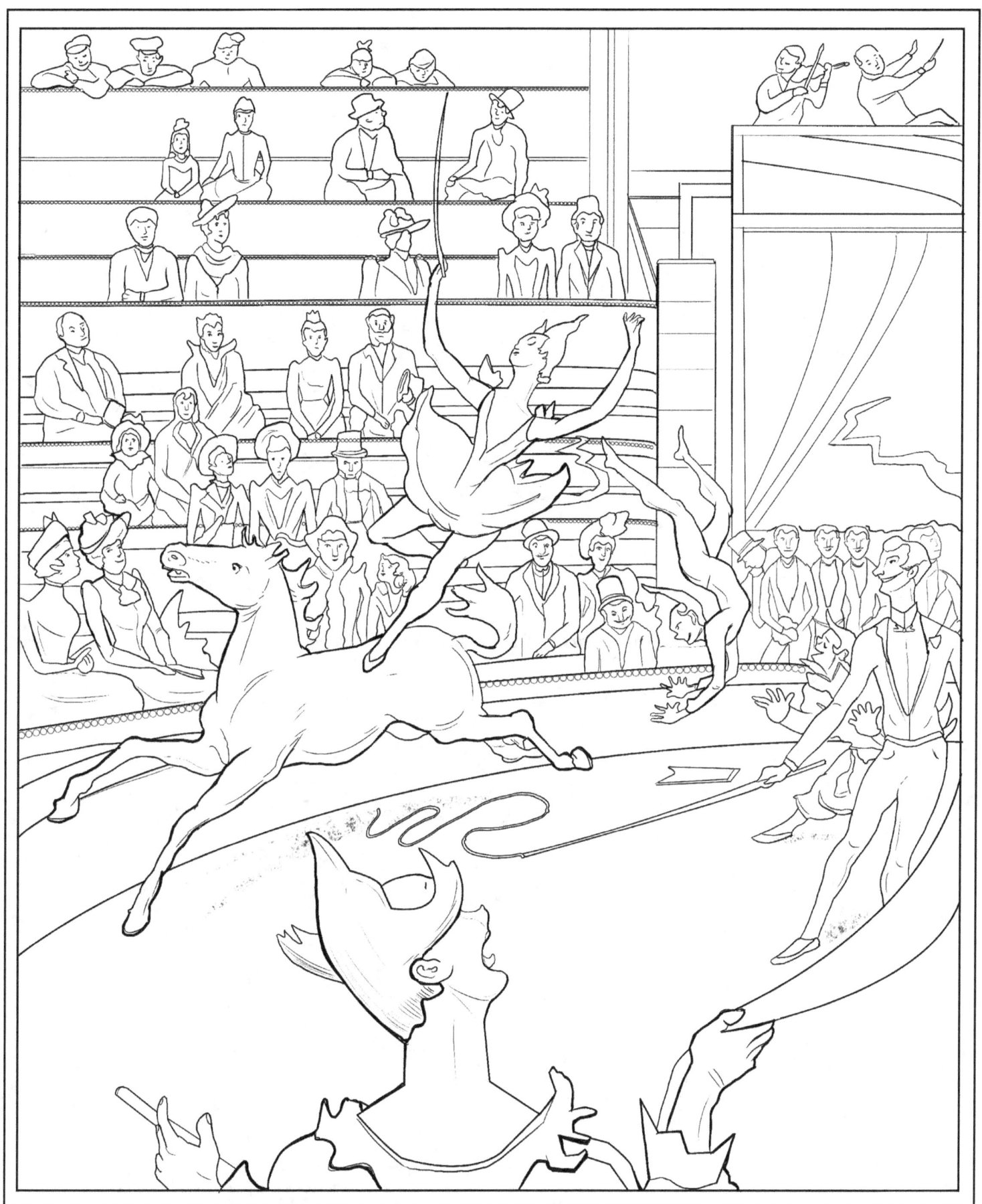

Plate 7.

The Circus, 1891, Musée d'Orsay, Paris

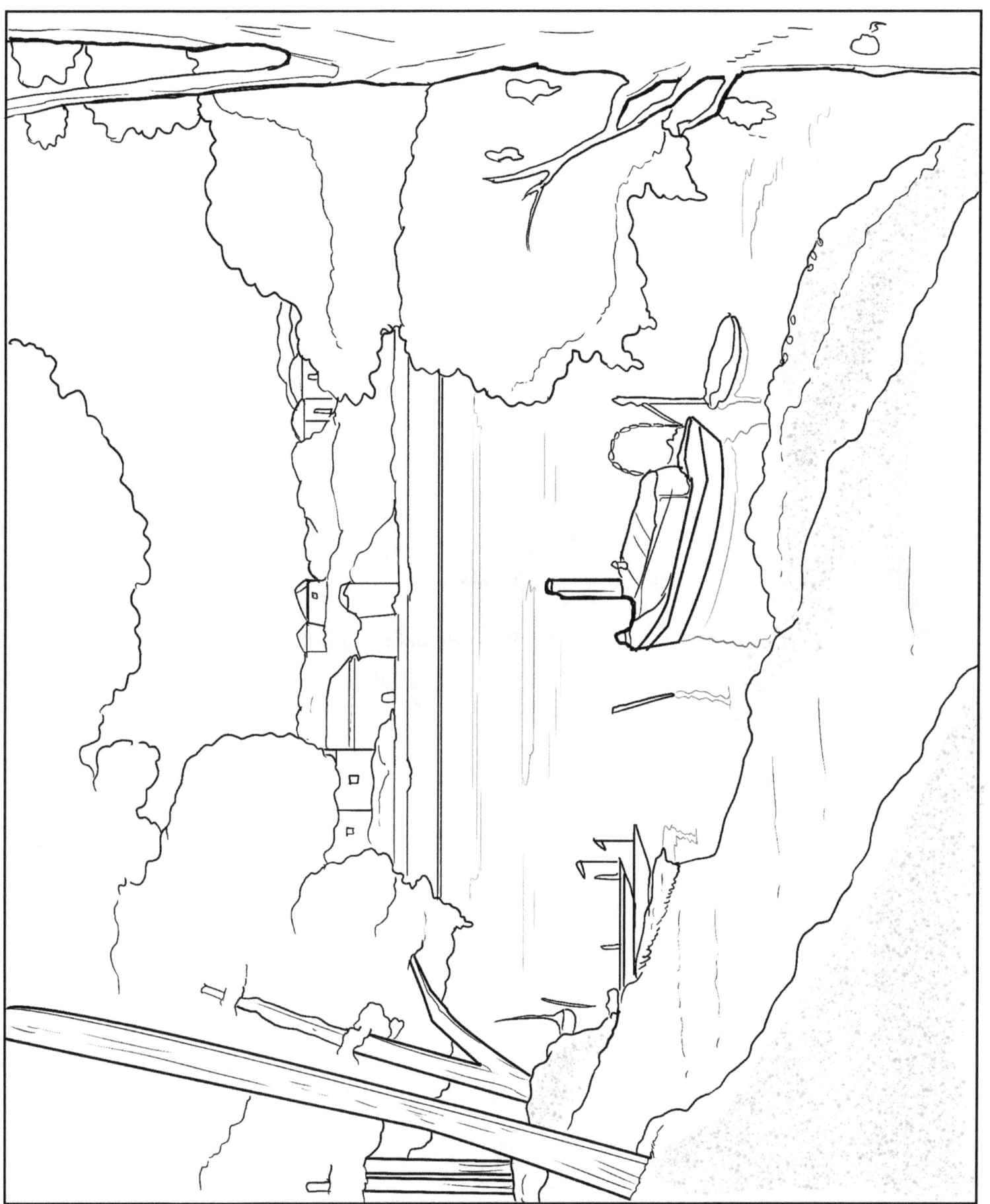

Plate 8.

Gray Weather, 1888, Philadelphia Museum of Art

ABOUT THE BOOK

Seurat was one of the greatest artists of his time. Discover some of his greatest masterpieces through this gorgeously illustrated collection of paintings formatted specifically for coloring.

www.ingramcontent.com/pod-product-compliance
Lightning Source LLC
Chambersburg PA
CBHW081320180526
45170CB00007B/2783